mehndi

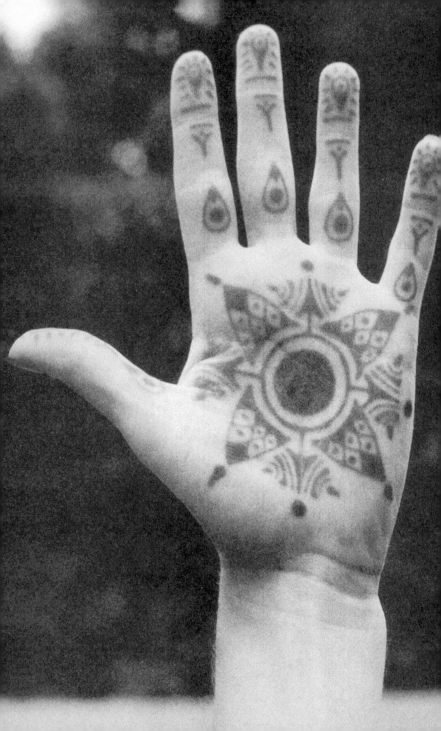

mehndi

the

art

of

henna

body

painting

By

Carine Fabius

Photographs by Michèle Maurin Garcia
and Pascal Giacomini

THREE RIVERS PRESS • NEW YORK

Published by Three Rivers Press, New York, New York.
Member of the Crown Publishing Group.

Random House Inc. New York, Toronto, London, Sydney, Auckland
www.randomhouse.com

THREE RIVERS PRESS is a registered trademark and the
Three Rivers Press colophon is a trademark of Random House, Inc.

Printed in the United States of America

DESIGN BY JANE TREUHAFT

Library of Congress Cataloging-in-Publication Data
Fabius, Carine.
 Mehndi : the art of henna body painting / by Carine Fabius ;
photographs by Michèle Maurin Garcia and Pascal Giacomini. —
1st ed.
 1. Body painting. 2. Henna—Folklore. I. Title.
GT2343.F35 1998
391.6—dc21 97-44146
 CIP

ISBN 0-609-80319-0

20

For my mother, Mireille Fabius,
who always encouraged me to write

acknowledgments

I wish to thank my husband, Pascal Giacomini, for his unfailing support; my friend David Fox, for his guidance; my good friend and artist Carla Cummings, for her participation and for being there when I needed her; Jayshree Nensey, for her openness; artist John Henning, for his talent and kindness; Devora Polakoff, for her generous gift of time; Suesan Stovall, for her faith in my abilities; and Michèle Maurin Garcia, for her wonderful spirit.

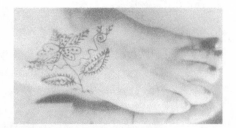

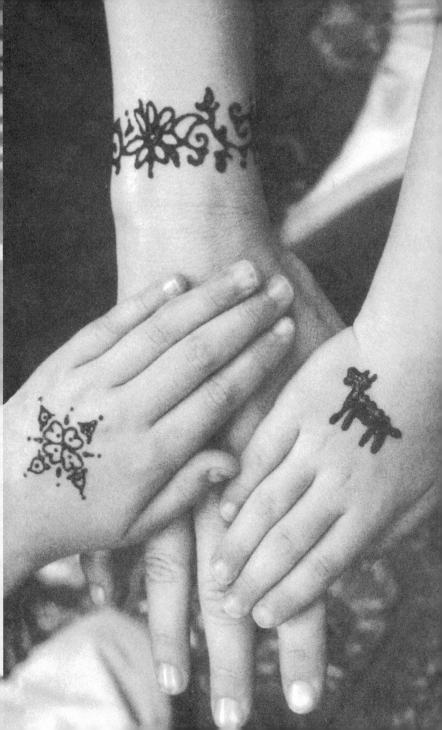

contents

introduction

In January 1997 my husband and I took the bold and risky step of opening the first space in the United States totally dedicated to the art of mehndi. There we were, art dealers selling Caribbean and Latin art, when this art form from India, Africa, and the Middle East entered our lives. As most people know, selling art for a living means you have to love what you do because often your love of art is the only thing that keeps the engine running. We had been operating Galerie Lakaye for six years, and my husband and I would regularly wonder when that cycle of fast and furious sales followed by long periods of inactivity would even out. We are committed to the art business because we are true art addicts, but I in particular was asking the universe for a change in our business affairs. I didn't really know what kind of change, I just felt that things needed shaking up. Know that saying about being careful what you ask for? Before long we were nose deep in henna and I knew I was entering a new, chaotic, and exciting period of my life.

A New York woman named Loretta Roome had curated a photographic exhibit and live demonstration of mehndi called The Mehndi Project in an East Village gallery in New York, and she wanted to bring it to the West Coast. When she first spoke to me on the telephone about the possibility of our hosting the exhibit in our gallery, she warned me about the nonstop activity to come. "Fasten your seat

RIGHT: The right hand shows an actual *vévé*, the Haitian Vodou symbol of Spirit of the Crossroads. Notice the similarities with the left hand, a typical mehndi design.

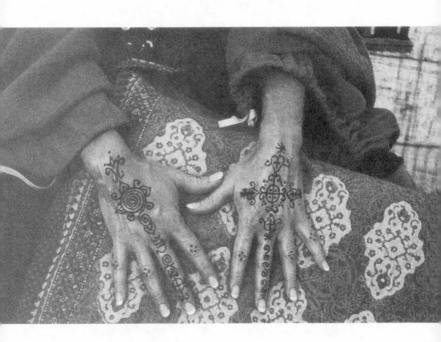

belt," she advised, and she wasn't kidding. After grappling
with the question of why a Caribbean art gallery should get
involved with an East Indian art form and coming up short,
we decided to throw common sense to the wind and follow
our instincts. My husband and I took a trip to New York and,
upon entering the Bridges & Bodell gallery, we had the
answer. I am from Haiti, and although I don't practice the
Vodou religion, I am both familiar with it and quite fasci-
nated by it. Before a Vodou ceremony begins, the priestess or
priest will draw on the ground with white chalk the symbol
(or *vévé*) of whichever spirit or god she or he hopes to attract.
There are many of these gods and goddesses, and their sym-
bols are as varied as their personalities and characteristics.
The curves and lines of these drawings are usually graceful,
sinuous, and filigreed affairs that are beautiful to behold.

When I walked into the gallery I saw drawings on the floor done in white paint that were dead ringers for the Haitian Vodou *vévés* I just described! These drawings turned out to be large representations of typical mehndi designs. Indians do it too, I thought, perhaps for different reasons, but there they were, what I felt sure was a sign. So we embarked on

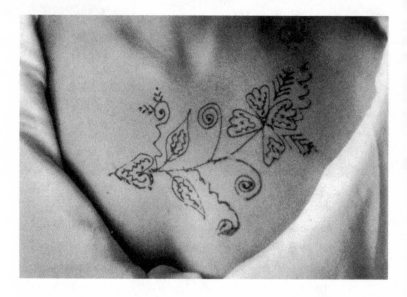

this journey—a very beautiful journey that introduced me to new worlds, cultures, and traditions. And I'd like to share my experiences and knowledge of this ancient art form with you.

Once open, the Galerie Lakaye Mehndi Studio expanded rapidly, thanks to the popularity of mehndi and the enormous amount of media coverage we received. As news of our work spread, I was handling not just hundreds of calls from people wanting to be painted, but calls from people all over the world wanting to learn how to perform mehndi, how they might offer it in their establishments, how they might go

about opening their own mehndi studio. The questions were endless and I didn't have many answers. But after a few months, one thing was clear: we needed to figure out a way to fill the great demand — demand for good-quality henna; for training; for information on the art of mehndi; for our experience, know-how, and techniques.

In the end, the best possible solution was to write this book. Hopefully, it provides the background information so many people crave: a detailed description of the mehndi application process, materials needed, step-by-step illustrations, and all the basics for enjoying this beautiful art form at home. So let's get started!

LEFT: Mehndi looks beautiful on the chest but won't last as long on hands and feet.

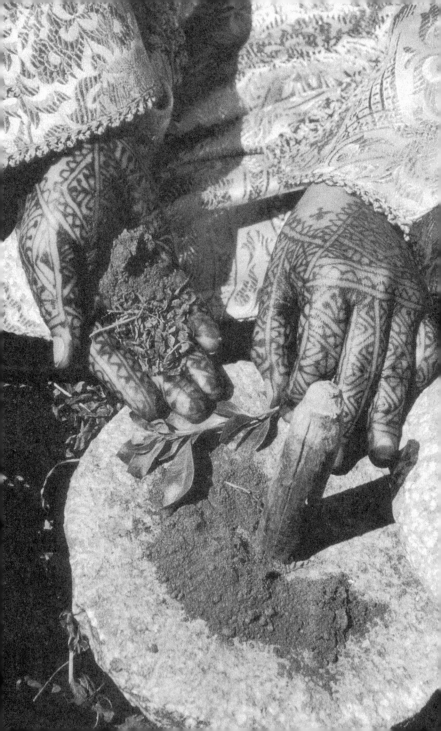

History
of
mehndi

and
Traditional
Uses
of
the
Henna
Plant

I like to think the reason the art of mehndi is so popular in the West today is because there's true magic in it: loving, positive, enriching magic. There is magic in the practice, the rituals, the superstitions, the ceremony, and the culture surrounding it. There is magic in the powerful and enchanting hues of crimson, burnt tobacco brown, and sunset russet that emerge onto bodies, turning an ordinary pair of hands and feet into bejeweled slippers and gloves of sultry brocade. And there is magic in the henna plant itself.

Practiced for five thousand years throughout India, Africa, and the Middle East, the act of painting the body with preparations made from the crushed leaves of the henna plant, whether it be in preparation for a special occasion or in celebration of a particular event, has always been done with the assumption or fervent wish that the act would engender good fortune, happy results, and good feelings.

EUROPE

Turkey

Iraq Iran Pakistan

Morocco

Algeria

Libya Egypt

Saudi
Arabia

Nepal

Mali

Niger

Sudan

MIDDLE
EAST

Indi

Senegal

Ethiopia

where

henna

is

used

AFRICA

(shading denotes areas
where henna is not used)

Henna, which is known for its power to protect, to bring luck, and to provide material as well as spiritual wealth, is used in all ceremonies having to do with rites of passage. The newborn baby who is about to be named, the young boy who is to be circumcised, or the young child who at the age of seven will be allowed to join in the ritual of fasting, usually for one month at daytime, will have their hands dipped in henna. Throughout the deserts of North Africa, red palms signal a young person's graduation to a new and important chapter in his or her life.

NORTH ASIA

CHINA
and
neighbors

In general, henna is thought of as a lucky charm or blessing. It wards off the evil eye, guards against black magic, harmful genies, and all other dangerous supernatural forces or entities. Its positive and evil-stopping powers gave birth to the ancient Arab proverb "If I don't speak the truth, I won't present my hand for henna."

In the north and western parts of India, the desert areas where the henna plant grows, mehndi (or henna painting) is a very important part of the wedding ritual and ceremony. As the story goes, the deeper the color obtained on the skin, the longer the love between the couple will last, hence the belief that a proper mehndi application is tantamount to a prayer to

the gods for everlasting love and a successful marriage. In truth, that belief is based in the centuries-old wedding traditions of India that are still practiced today.

The day after the wedding, a bride goes to live with her husband and his family. Men always live with their parents, even after marriage, because they are expected to take over the duties of caring for the family (another reason why sons are so revered over the daughters who will eventually leave to be with their husbands' families). During the first month of marriage, the bride is not expected to cook, wash dishes, clean the house or herself — maids take care of bathing and all other bodily functions — so that she can use this time to get to know her in-laws and to learn the ways of their household. The new bride doesn't use her hands at all, and hopefully as a result, her mehndi will last at least a month, a good omen. And since her in-laws don't allow her to help with chores, the myth instructs, they must necessarily love her very much, and by extension, so must her husband. Thus, the longer the mehndi lasts, the more love there is all around!

Customs are different in Morocco, and brides do not necessarily cohabit with their in-laws. But seven months after the wedding, the new Moroccan bride visits her in-laws, who rejoice in her visit, offering her many gifts, including a henna session. When she returns one year later, the henna marking offered to her, always in the palm of her hand, represents a symbol of stability, a symbol often found in jewelry worn to ward off evil spirits.

RIGHT: **The delicate balance of this intricate and ornate design is typical of Mehndi artists from Morocco.**

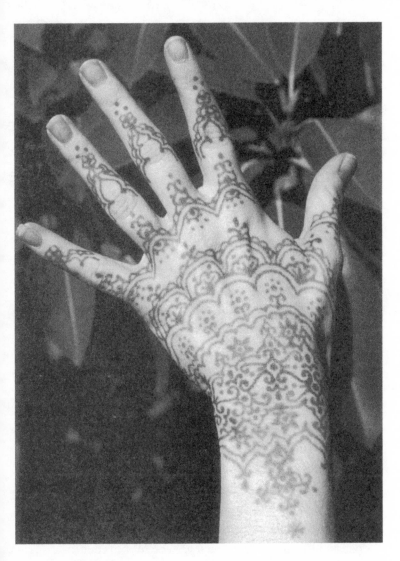

Pregnant Moroccan women in their seventh month seek out well-respected henna practitioners called *hannayas* in order to have certain symbols painted on their ankle, which will then be encircled with a corresponding amulet. The

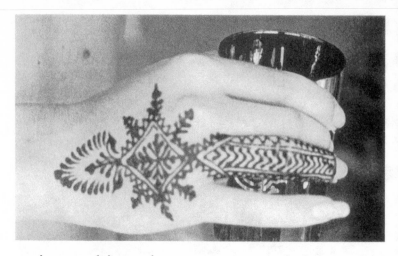

henna and the amulet are meant to protect both the mother and child through birth. Once the baby is born and the umbilical cord severed, a plaster of henna, water, and flour is placed on the newborn's belly button in order to ensure beauty and wealth.

The Berbers, ancestors of Morocco's first inhabitants, live today much the way they did centuries ago, as herders, farmers, potters, ceramists, and weavers. Among this race of simple nomadic peoples, faith in the supernatural is a way of life, and *baraka*, the positive power of the saints, is said to exist in many animate and inanimate objects, like amulets, jewelry, textiles, and plants. The henna plant especially is believed to be permeated with *baraka*. It is common for a bride's hair to be dressed with a henna paste on her wedding day by a "woman who is happy," who informs her in singsong ritualistic fashion that she is being painted with the

ABOVE: The detailed design on this hand varies from traditional designs, which usually cover the entire hand. RIGHT: The design on this foot is intricate without being dense.

"plant of happiness" so that she will be able to rule happily as the lady of the house.

When a soldier goes off to war, he has his wife apply henna to the palm of his right hand for protection and to remind him of her love.

In death, too, henna is used in these regions. For example, when a man dies his head is sprinkled with henna, and the hands and feet of a deceased woman are painted with henna in order to ensure happiness on the other side. It is also customary for the family and friends of the departed to dip their hands in a henna paste at the funeral. This will help them overcome their grief and to surrender to the divine will that is responsible for their loved one's passing.

In Morocco as in India, men do not usually participate in mehndi rituals and ceremonies. For the most part, it is a feminine art form, practiced by women on women, except for widows, who are strongly discouraged from sharing in

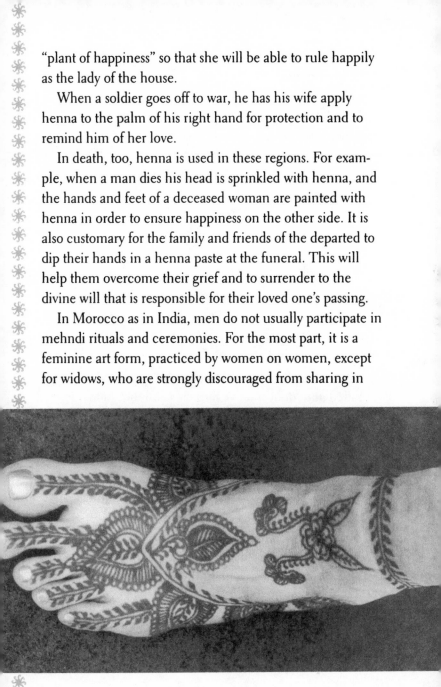

henna traditions. A North African widow cannot use henna for four months after the death of her husband. In India, a widow never touches henna, because when the husband dies a woman is no longer supposed to have any fun. In that respect, widows are never invited to social functions, and a new bride should never look at or be seen by a widow because it is considered bad luck. Some women just don't have *any* luck!

Mehndi, or henna — the terms are used interchangeably in India — is taken very seriously in the desert regions. In the south and eastern territories, such as Pondicherry, Madras, and Calcutta, where rivers run rampant and rain is plentiful, henna is not available and people are not used to the mehndi practice. Instead, eastern Indians use a reddish ink called *alta* for decorative purposes and they paint only bold, simple designs. Southerners make wide use of the bark of sandalwood trees to make a yellowish brown paste, which is also used for decorative painting of *tilaks* or *bindis* between the eyes for prayer purposes. In fact, the Indians from the east mock northern henna users with their intricate, flowery designs.

Although mehndi is widely practiced for body decoration on birthdays, anniversaries, weddings, and baby showers, as well as by dancers and performers (they, too, use only bold center designs on the palms so the audience can see it from

RIGHT: **A likeness of Kali, the Divine Mother, will accompany this lucky woman wherever she goes for weeks.**

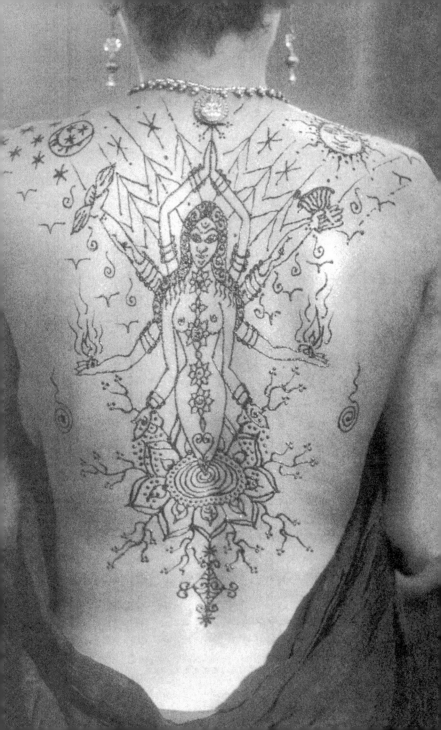

far away), it is considered a meditation and spiritual practice. It is never done carelessly and is always performed with an eye to the gods. For example, an Islamic person will never paint animals, faces, or figurative designs on her hands, because they pray with their arms open wide, hands pointing to the sky, palms facing the eyes. Only abstract floral and vinelike designs are permitted because they do not distract from the prayer at hand. Hindus, however, pray with closed hands; therefore their hands can be adorned with the design of their choice.

A religious symbol, such as an om, a cross, or swastik, the sign for purity, will never be painted on the feet, because Lord Vishnu is said to have been born from Lord Brahma's navel in a lotus. This is why the lotus is India's national flower and only what is above the navel is considered holy. Incidentally, this is also the reason people who go to the Ganges River to pray only go in waist deep.

Believe it or not, the practice of mehndi started out as an answer to the need for air-conditioning in the desert. The henna plant, whose botanical name is *Lawsonia inermis* and which comes from the *Loosestrife* family, has several medicinal properties, chief among them its ability to cool down the human body. When the desert people of Rajasthan, Punjab, and Gujarat became aware of henna's cooling properties, they dipped their hands and feet in a mud or paste made with the crushed leaves of the plant. Even when the mud was scraped off, they noticed that as long as the color remained visible, their body temperatures stayed low. Even-

tually some women grew tired of bright red palms and found that one large central dot in the palm of the hand had the same effect, while being more pleasing to the eye. Other, smaller dots were placed around the center dot, which gradually gave way to the idea of creating outright artistic designs. To that end, a thin instrument made of silver or ivory (in India) or wood (in Morocco), then most commonly used for applying kohl to the eyes, became the instrument of choice for henna applications, and it is still in use in desert villages today. Only in the last decade or so have the popular Indian cone (see page 44) and Moroccan syringe, both of which are able to deposit the thinnest filaments of henna onto the skin, come into play as modern counterparts of the simple stick.

In addition to its cooling properties, henna is attributed with other medicinal properties. It is used as a coagulator for open wounds, and a poultice made with henna leaves works to soothe burns and certain cases of eczema. Its inherent soothing qualities are also part of the reason why mehndi is traditionally performed on the palms of the hands. Since the palm contains numerous nerve endings, when henna is applied to the area it helps to relax the system. A plaster made of henna works like an antiperspirant in that it works to tighten pores; this same plaster shows its antibacterial characteristics in that it helps reduce halitosis. Henna is also known to work internally against diarrhea and externally against leprosy, smallpox, jaundice, and certain cancers. Finally, henna mixed with vinegar and applied to the head is reputed to heal headaches. Aspirin, move over!

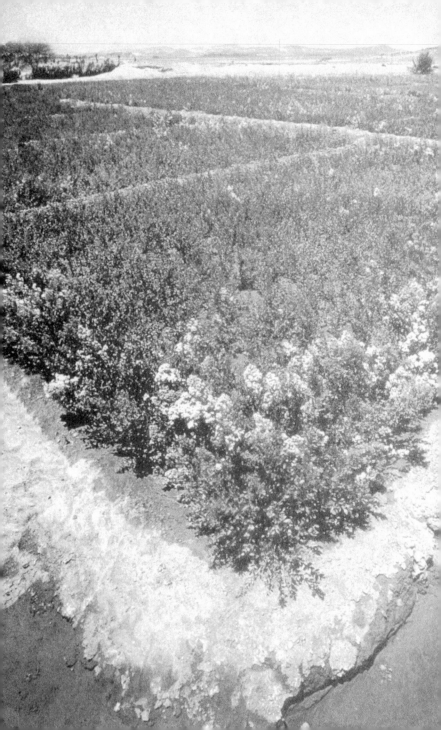

the henna plant

Those who have already come into contact with powdered henna are familiar with its undeniably special smell, a powerful and heady combination of earth, clay, chalk, and damp green leaves. In contrast, fresh henna leaves have no odor whatsoever, even when crushed between the fingers. The henna flower is delicate, petite, and four-petaled, with a profusion of slender and elongated antennas bursting from the center. The red, rose, and white variations of the blossom, which also blooms yellow, cream, and pink, emit a sweet and seductive scent reminiscent of jasmine, rose, and mignonette, hence the name Jamaica Mignonette, as henna is referred to in the West Indies. Although the plant's primary uses lie elsewhere, the flower's oil has been used as a perfume for many centuries (although its fragrant secret has yet to be popularized in the West).

The henna plant itself grows on a bush or shrub approximately ten feet high with small bright green leaves and a thorny bark. Although the bush can grow up to fifteen feet in height, it rarely gets that tall because it is harvested three times a year. When it reaches about 1½ feet, it is chopped as close to the base as possible with a serrated knifelike tool with a rounded tip. The branches are broken by the handful and placed into a large sack, which is then taken to another area where they are laid out for two days to dry in the sun. The leaves are shaken off the branches, gathered up, and placed in large bags made of plant fibers and then taken to

LEFT: A field of henna.

warehouses, where they await a buyer. Sales are usually made to wholesalers, who may take the henna to other towns across the country and resell it either in its dried leaf form or in powdered form to women and small vendors who will sell it for a retail price at public marketplaces alongside other herbs and spices. At the market many customers prefer to buy it in leaf form. By buying the product in its primary state, the customer can rest assured the henna has not been mixed with other plants. The leaves are also less costly than the powder. For those customers, the leaves are either taken home for grinding or ground before their eyes into a powder with a mortar. For customers purchasing henna in its powdered form, either because they don't have the time to grind it themselves, can afford to buy it already ground, or are buying it for export purposes or use in beauty salons, the sacks of leaves are taken into town to the local mill. Before being ground, the leaves are sprayed with small amounts of vegetable oil to help prevent overheating of the multiblade grinder and to reduce the amount of dust generated from the process. A mill employee, who is usually covered in green powder from the grinding process, then shovels the henna powder onto the concrete floor of the mill, spreading it out in order to cool it down before packaging.

The henna plant originally comes from Egypt, a country which is still one of the main suppliers of the plant along with India and the Sudan. In Egypt, henna is referred to as Egyptian privet. Egyptian privet made its way over to India as

a gift from the ancient Egyptians, and it is said that Mumtaz was the first Indian queen to be painted with henna. Beloved wife of Shah Jahan, who governed as emperor from 1628 to 1631 during the rule of the Mughals, Mumtaz is buried in the resplendent Taj Mahal, where today mehndi artists can be found on a daily basis offering their services to passing tourists. But the graceful, sinuous designs of India are nowhere to be seen on Egyptians, whose own henna markings are much more geometric.

Henna was also commonly used to dye the manes and hooves of horses and to color wool, silk, and animal skins, as well as men's beards. Studies of mummies dating back to 1200 B.C. show that henna was used on the hair and nails of the pharaohs. In Saudi Arabia, the great prophet Mohammed was said to have dyed his hair with henna, which resulted in its usage as a sanctioned and popular practice in the year 632 B.C. In China, the use of decorative henna on nails is also documented, as is its use on the teeth of Vietnamese women who liked to lacquer their teeth black. When mixed with other blackening agents, henna helped achieve the same results in a more economical fashion. In all, henna is probably the most oft used cosmetic in the history of time!

BELOW: The henna flower blooms in yellow, cream, and pink.

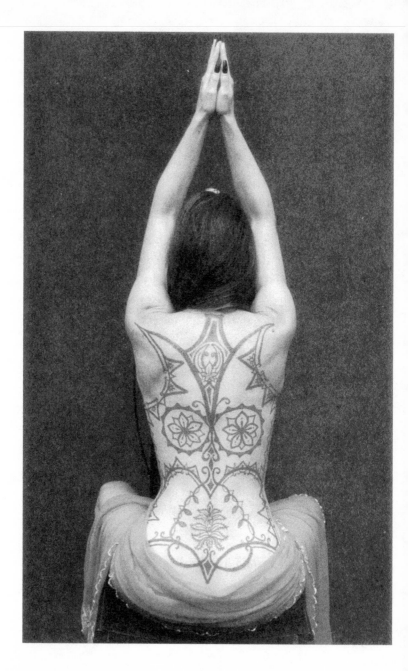

henna today

Until the art of mehndi became hot news in 1996, henna was mostly used in the United States as a hair dye. Widely recognized now as a wonderful way to dye the skin and to achieve the look of a tattoo, traditional henna uses and application processes have gone contemporary. Although some will always prepare their own henna paste, mehndi kits of varying quality, with foolproof instructions and convenient stencils, can be purchased in many retail outlets. And even the henna paste itself, which always loses its dyeing properties after three days, is now available through our studio, with a four-week shelf life.

frequently asked questions about mehndi

Why is this five-thousand-year-old art form suddenly enjoying such popularity in the West today?

While it is true that mehndi might be the most recent ancient art form to be discovered in this day and age, for many well-traveled Europeans and Americans, mehndi certainly isn't new. Morocco and India have always been popular tourist destinations and the practice of mehndi is everywhere to behold, in marketplaces and outside of tourist attractions like the Taj Mahal. So when mehndi made the

LEFT: Mehndi is a great way for performers to achieve a dramatic effect and capture attention.

headlines in the States, then in Europe, for many it struck a chord; one that brought back pleasant memories of exotic holidays in faraway places. Another reason for its large following is the fact that mehndi emerged as a safe, painless, and socially acceptable way of tattooing oneself at a time when the art of permanent tattooing was reaching its peak, a peak that continues to maintain its high. And just as mehndi was making its entrée into the nation's consciousness, so was a renewed interest in Indian affairs, as evidenced by the recent rash of mainstream movies by Indian filmmakers released in the States and the renaissance of Indian literature and fashion, all just one year before the fiftieth anniversary of Indian independence.

But another part of the equation also lies with Loretta Roome, a New York–based artist, and her Indian teacher, Rani Patel. They organized a photography exhibit of mehndi on different areas of the body along with a live demonstration of the art form at an East Village gallery in the summer of 1996, and a barrage of media articles and television news programs soon followed.

It was a combination of the right product at the right time and the right place; and probably, the mehndi gods were ready.

How long does it last?

Although some henna designs may last up to a month, for the average person the designs will last anywhere from one to three weeks depending on the particular body area, how much that area is exposed to water, soap, rubbing, or chemicals, and a person's lifestyle. Henna is a capricious, mysterious, and elusive substance, and the color and depth of stain

depends on the area of the body on which it is applied, an individual's body temperature at the point of the design (the warmer the temperature, the longer it will last and darker the design will be), how well the paste is protected as it dries, and how long the paste is left on. The palms and soles of the feet tend to be the warmest areas of the body with the thickest skin, which allows for the henna to seep into multiple layers. It is interesting to note, however, that even though the color is deepest on palms and soles of feet, it may not necessarily last as long in those areas because they are constantly in use. Other good areas to decorate are the inner wrist and forearm and the tops of the fingers. The face and chest, where the skin is quite thin and exfoliates quickly, are the worst possible choices for mehndi applications.

What color will it be after the henna paste comes off?
Depending on the individual and type of henna used, the color will vary from light orange to a dark reddish brown.

Does henna come in black?
No. Oftentimes, the images of mehndi designs on the body presented by the media tend to show applications with the henna paste on, as opposed to how the final design looks when the paste is scraped off, and this is confusing. Many people want the look of a permanent tattoo and really *really* want black henna, so numerous mehndi providers have begun offering "black" henna to fill the demand, but these products can be dangerous to the skin. True henna color is reddish brown and any other colors are likely to be the result of dyes of one kind or another being added to the henna paste.

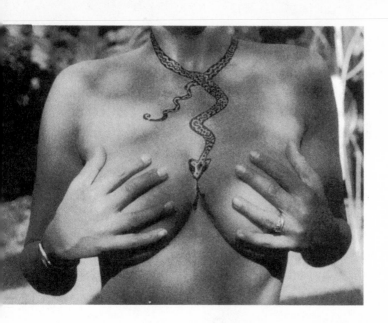

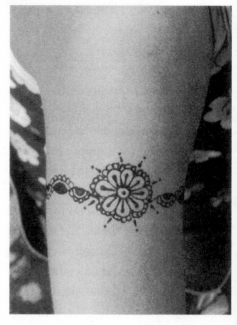

ABOVE: **A sinuous snake is a great necklace.**
RIGHT: **A simple floral armband is a nice alternative to hand and feet designs.**
OPPOSITE: **Painting a mom-to-be with henna is a wonderful alternative to traditional baby shower games.**

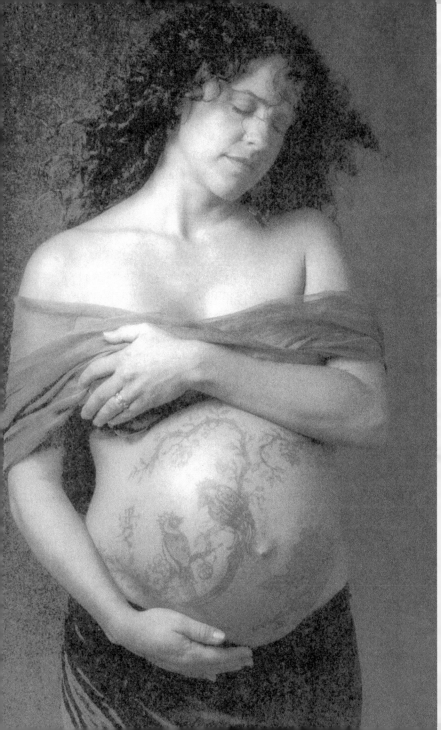

What about colored henna?

For the record, there is no such thing as colored henna. The color produced by the henna plant is a variation of reddish brown. Depending on skin tone, skin type, body temperature, and other factors, the color of henna appears on the skin as light orange, dark orange, reddish brown, cafe-au-lait brown, tobacco brown, chocolate brown to burgundy, and crimson red. As much as one might wish it otherwise, this is the color of henna. All other colors are either chemically engineered by mixing henna with hair dyes, other skin dyes, other plant dyes (whose successful results I have yet to see), or legally "natural" agents such as kerosene and battery acid. Some people use "kutum," which is described as "hair dye" in any Arabic dictionary, but is purported to be a plant from Algeria. In our Los Angeles studio, we use only 100 percent natural henna in all our mehndi applications. There are also other products on the market that appear on the body as blue, green, red, or even yellow; these claim to be made with natural plant dyes, which may be true, but they are not made with henna.

How long does it take?

How long the process takes depends entirely on the design; the length of a mehndi sitting ranges from thirty minutes for a simple anklet or palm design to several hours for a large body area painted with an intricate design.

Does it hurt to have it done?

Unlike tattoos, mehndi does not hurt because there are no needles used and the skin is never pierced. The paste is

applied on top of the skin. In fact, mehndi, which is an entirely natural herbal blend, even conditions the skin.

Are you sure it will disappear completely?
Yes. Skin exfoliates every twenty-one to twenty-five days, and the henna fades gradually over this period of time. Invariably some people complain of getting "no color." Often, this is because they do not follow directions properly, or they take the paste off too soon. However, some skin types just require a double application. I recommend a double application for people with darker skin, although it is not so much the skin *color* but skin *type* that is the determining factor.

Is there anything I can do to make it disappear more quickly if I don't like it?
You can scrub it every day vigorously, use suntan lotion on the area, swim in chlorinated water, and wash dishes with bare hands. But no matter what you do, there is no quick fix. And, rest assured, the marking *will* fade naturally over time. There is one thing you can do once the design has nearly faded completely. Rubbing the area with a cotton ball soaked in hydrogen peroxide works to totally remove remnants of your nearly gone mehndi design.

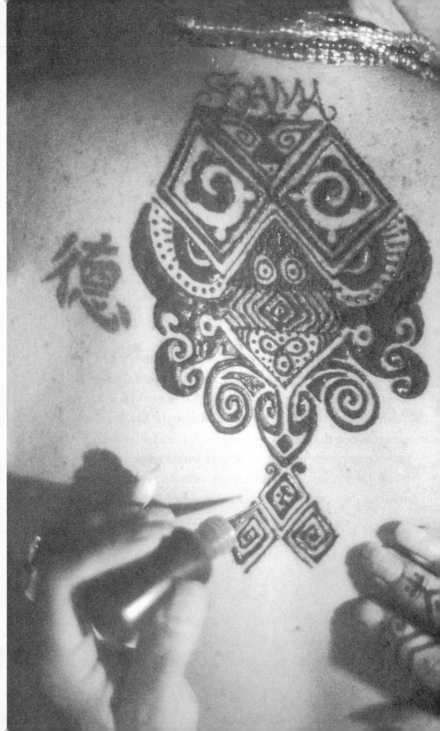

The mehndi
Process

Doing mehndi yourself is loads of fun, even if you are just a beginner. It is the kind of art form that encourages you to let your creativity run wild. With these easy-to-follow instructions and illustrations, you will learn the basics for creating simple designs, which, with an extra line here, an extra dot there, quickly become quite ornate and fancy. Make sure to read through all the helpful information in this section before you begin.

making the henna paste

Sifting the Henna

In order to avoid problems during the application process, you must sift the henna powder before attempting to make it into a paste. I would avoid using henna found in Indian grocery stores, because you never know how long it has been

sitting on the shelf and the quality is always hit or miss. I recommend you buy henna only from a reliable supplier (see Resources, page 102). Even though the powder you buy might look very fine, you will want to sift it just the same. Sifting is especially important if you want to achieve delicate designs using the thinnest, most delicate lines. Whether you use a cone or a bottle with a fine tip to apply the henna, if the powder is not properly sifted, the twigs and other debris often found in standard henna powders will clog the tips of your tools. Unfortunately, kitchen strainers and sifters found in supermarkets and department stores are not tightly woven enough, and you must use muslin cloth or nylon, such as pantyhose, for the sifting. Stretch the cloth of your choice across a bowl or jar and use a spoon to push the henna through. Fine twigs and other debris will remain on top of the cloth; throw them away. Another way of making sure that the powder will be the very finest is to put it through a coffee grinder first, then sift it through cloth or nylon. Make sure to wash out your coffee grinder before and after — henna and coffee don't taste so good together! Ideally, the ground henna should be the consistency of flour, or as close to that. as you can possibly get.

the recipe

If there are fifty different ways of baking a cake, there are as many ways of preparing a proper henna mixture for mehndi purposes. Every Indian or Moroccan family has a time-honored recipe, using ingredients that they are often loath to share. And who can blame them when its use is so widespread in those

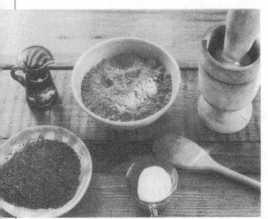

regions and when there are so many professionals in the field?! I myself have heard about or read about and tested at least fifteen to twenty different recipes, and the one shown here is the easiest, most effec-

tive, and least costly. Keep in mind, though, that like many good recipes, mixing a henna paste is not always an exact science. Mostly, it's a little of this and a little of that until you reach the consistency that's just right. It should be similar to that of toothpaste, which is firm yet soft enough that if the tube is left uncapped, it will fall out after a slight delay.

The following recipe makes approximately ¾ ounce of henna paste, which should yield 15 to 20 applications of simple designs like bracelets or anklets. I use the ¾-ounce measure because it is enough to fill an average cone — the most commonly used method for applying henna in India — or the handy ½-ounce plastic applicator bottles we use at our studio, with plenty left over for refills.

> 1 **cup water**
> 2 **tablespoons black tea**
> 3 **teaspoons powdered and sifted henna**
> 1 **teaspoon eucalyptus oil**

Bring the water to a boil in a microwave (3 minutes should do it) or boil the water on the stove the old-fashioned way. When the water boils, turn the stove off or remove the cup from the microwave and add the black tea, the blackest you can find, to the water. Ideally, the tea should be left to steep in the water overnight, so it is best to do this just before going to bed. Remember, you should steep the tea in *already boiled* water. If you are patient enough, you will continue this process the following morning; if you are impatient, start the tea steeping at any time of the day and let it steep in the water at least 2 to 3 hours before continuing. Make sure to pour the tea through a strainer to avoid getting tea leaves or sediments into the henna.

Pour the sifted henna powder into a plastic bowl and add the eucalyptus oil to the powder. Do not mix! Add approximately 3 tablespoons of the tea to the henna powder, a tablespoon at a time, and stir the ingredients together with a small silver or metal spoon. It is impossible to say exactly how much tea to add to the henna powder and eucalyptus oil because some henna powders require more moisture than others. Using the back of the spoon, press the mixture into the sides of the bowl, working to get the grittiness out of the paste. Do not worry about the paste being too lumpy because it will be

smoother by morning. Here again you must be patient and allow the paste to set for 12 hours. Cover the bowl with plastic wrap, then seal it shut with a lid that will keep the mixture in an airtight environment (a Tupperware container is ideal). Place the sealed container away from the light, like in a kitchen cabinet, and leave it alone for 12 hours for best results. If you are impatient, let the mixture set in this way for at least 4 to 5 hours and use a spoon to take away any remaining lumps. You will know for sure if you have reached the proper consistency once you actually apply the paste with your applicator bottle or cone (see page 44). If the paste is too runny, just add a little henna powder, and if it is too dense, just add water or some leftover tea, a few drops at a time, and shake. The henna paste is now ready to use!

Fresh henna only lasts two to three days at best, so do the mehndi immediately after the henna paste has set. Whatever is left can be refrigerated, but after three days, it will have passed its prime, even though it may look exactly the same. Using old henna will result in a very light color on the skin or color that fades in just two to three days.

Do's and Don'ts to Make Your Design Last

Don't wet the area for several hours after taking off the mud. **Don't** use suntan lotion or sunscreen on the area. **Don't** do any scrubbing, use harsh lotions, or expose the skin to chlorinated water. **Do** use gloves when washing dishes.

preparations

Making a Cone

There are many ways of applying henna: syringes, toothpicks, BBQ skewers, needles, pastry bags, and any other creative solutions you can think of. Really, your imagination is the limit! However, the most commonly used method throughout India is the cone. For those who want to go the traditional Indian route (in North Africa the syringe is preferred), what follows is a step-by-step process for making a mehndi cone. You will need Scotch tape, scissors, and a plastic drop sheet, the kind used to cover floors when a house is being painted. Most paint and home supply stores sell them in rolls. Follow these steps carefully and refer to the illustrations for help.

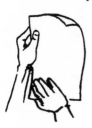

1. Cut a 4 × 5-inch rectangle out of the roll of plastic.

2. With your left hand, hold this sheet with your thumb and index finger a third of the way down from the top on the left-hand side.

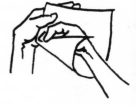

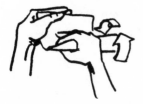

3. With your right hand, take the bottom left corner of the sheet and fold up into a line that aligns with your thumb and index finger, creating a shape that looks like a triangle.

4. Using your right hand, twist that corner into a cone shape. Twist until the bottom tip of the cone has absolutely no hole. If you look inside the cone, you shouldn't even see a hole the size of a pinprick! This may take some practice. Keep twisting the plastic into a cone shape until the material is used up. When you are done, to gauge that the cone is the proper size, you should be able to fit no more than two fingers into the top of the cone.

5. Using Scotch tape, tape the edge closest to the bottom tip of the cone to the body of the cone. Do not put tape around the tip! Tape the edges down in two or three other spots on the cone as needed.

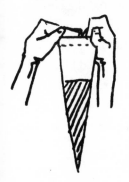

6. Using a small spoon, ladle the henna mixture into the cone until two thirds of the cone is filled. Do not fill it up to the very top.

7. Fold the top of the cone down once so that the pointy end of the triangle comes down over the body of the cone. Make one more straight fold.

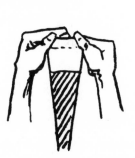

8. Take each of the two corners of the top of the cone and fold them in at 45- 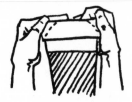 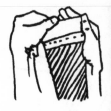 degree angles. Fold in once more and tape the sides down with Scotch tape.

9. Fold the top of the cone down one final time over the folded edges and tape to the body of the cone. Place the tape wherever you judge necessary to avoid leaks.

10. Using sharp scissors, cut a little piece of the pointy tip of the cone off, making as tiny or as large a hole as you wish, depending on the thinness or thickness of henna lines desired.

11. For proper henna applications, do not hold the cone at an angle like a pen or pencil. Hold the cone on top, tip facing straight down at the surface to be painted. It is best to squeeze henna out from the top where it is taped to avoid henna spilling out from the sides.

Do not despair if it doesn't come out perfect the first time! Making a cone takes practice.

RIGHT: A mehndi artist creates a lotused hand using a plastic squeeze bottle and fine metal tip.

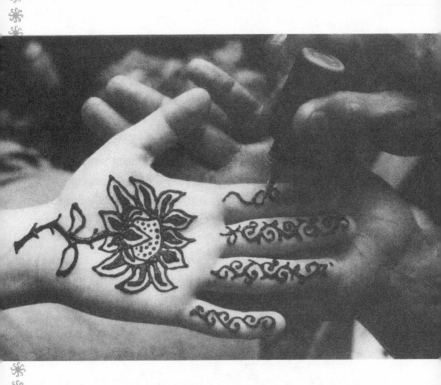

Plastic Applicator Squeeze Bottles

Most artists find that using Jacquard ½-ounce plastic applicator squeeze bottles fitted with small metal tips are the easiest of all. These bottles, commonly used for silk-screening, can be found at most art supply stores. The tips come in sizes .5, .7, and .9, .5 being for finest lines and .9 for thicker lines. Both bottles and tips are very inexpensive.

Filling these small bottles with the henna paste can be tricky. The best system we found is to spoon the henna paste into a plastic sandwich bag (choose a bag that is fairly sturdy over the cheaper, thinner ones on store shelves). When doing this procedure, *I highly recommend you wear latex gloves* to avoid getting henna on your hands. From the out-

side of the bag, use your hands to push the henna into one corner. Cut the tiniest hole possible at the bottom of that corner, turning it into a pseudo pastry bag. Hold the bag up above the bottle opening and squeeze. If done right, a thin line of henna will go straight to the bottom of the bottle and fill it up very quickly. When necessary, stop and tap the bottle down on the counter to make the henna settle at the bottom and continue filling. When the bottle is almost filled, henna may tend to gather around its mouth. Gently squeeze the sides of the bottle. This will result in the henna being drawn into the bottle very easily.

When using these plastic bottles to apply mehndi, make sure to refill them with henna when you get to the halfway mark, otherwise the pressure on the hand to squeeze the paste out becomes too intense. It is always easier to work with a full bottle. Also, at the end of the day, it is a good idea to consolidate half-empty bottles into other bottles, and to wash out empty bottles by filling them with warm to hot water and shaking vigorously. Soak the tips in warm to hot water overnight, otherwise they will become clogged with henna. Also, in order to get every last drop of henna out of the bottle, keep it upside down in a cup when not in use. You will want to refrigerate any remaining henna in order to preserve it for a few days; just let it warm up to room temperature before you begin.

necessary supplies and materials for henna application

Eucalyptus Oil, Mustard Oil/Olive Oil, or any other Vegetable Oil

Eucalyptus oil can be found in most health food stores. Mustard oil, which is more difficult to find, can be obtained at Indian grocery stores; if you don't have one in your neighborhood, eucalyptus oil works very well. Either of these oils can be used before and after your henna application. Some people are known to have allergic reactions to eucalyptus oil, so it is advisable to test it on a small area of the skin before use.

Since both eucalyptus oil and mustard oil tend to be expensive, I would recommend using them on the skin only before applying the henna when just a few drops are needed. When the time comes for removal of the dried henna paste, olive oil or any other vegetable oils are fine alternatives since you will need much more of it to help dislodge any stubborn henna residue. Do not use baby oil or any other mineral oils; make sure to use only edible oils.

Lemon and Sugar

The strained juice of half a fresh squeezed lemon mixed with 1 teaspoon of sugar will be needed to set the design in place. The citric acid in the lemon helps the henna to seep into the skin while the sugar helps to create a sticky glazelike coating, which works to keep the design in place as it dries. In a pinch, concentrated bottled lemon juice found in most supermarkets and grocery stores can be used in place of fresh lemons.

Cotton Balls

Make sure you buy 100 percent cotton balls! I have seen 50/50 mixes of cotton balls on the market, but these will not help you as they do not absorb as well. You will need cotton balls to apply the lemon-sugar solution to the design after it dries. You will also need them to remove the henna paste from your skin when the time comes.

Cotton Swabs

Cotton swabs, like Q-Tips, are used to wipe away mistakes. And you will make them, whether you are an expert or beginner mehndi artist. Smearing of one section of the design can often happen as you work to finish another section. Or you may not like the way a certain line comes out, or if the tip of your tool clogs, which happens all too often, you might end up with a blob of henna on your skin from squeezing your instrument to get the henna to come out. In any of these situations, the swabs are the perfect tool for quickly wiping the henna off in one fell swoop. And you'll want to move quickly because henna starts to stain the skin almost immediately. Use swabs that are 100 percent cotton.

Flat Toothpicks

Flat toothpicks are great for evening out lines that come out crooked if your hand is unsteady. They are also perfect for thinning out a line that you may find too thick. Toothpicks are great for editing and they may be the most important and most often used instrument of all. They are a mehndi artist's *must-have* tool.

Paper Towels

You will use these repeatedly to wipe off the toothpick you use to clean your design. Paper towels are also handy for wiping off the mouth of the tip, as a surface for testing the flow of henna out of the cone or bottle; and for use as an apron on your lap when applying henna. You will also probably get some henna on your hands while you work, and you'll want to wipe it off as soon as possible to avoid having unsightly orange hands.

Straight Pins

Another *must-have* tool for a mehndi artist. When the fine tip of the cone or bottle's metal tip clogs, as it inevitably does, straight pins are lifesavers. Usually one jab of the pin through the tip is all it takes to unclog it. Often clogging happens if a tip is not properly cleaned out and has dried henna on the inside. As mentioned earlier, improperly sifted henna also slows things up with clogging. But even if the henna is properly sifted, you may still get the occasional stray twig that tries to come through the tip and fails. Keep some pins handy!

Glass or Ceramic Bowls

If you are planning to apply mehndi to several people or if you plan to apply mehndi on a professional basis, it is easiest to use several glass or ceramic bowls for cotton balls, cotton swabs, toothpicks, eucalyptus oil, and lemon-sugar solution. If you are just applying mehndi on yourself, you may not need bowls for all the supplies just mentioned. However, you will need one for the lemon-sugar solution.

Toilet Paper and Scotch Tape

For best possible results when using a fresh henna recipe, it is necessary to leave the henna paste on your skin for twelve to twenty hours after its application. Often this means leaving it on overnight. In order to keep the design in place while you sleep, to avoid smearing, and to make sure your bed-sheets will not get stained, it is best to wrap the area with toilet paper and Scotch tape. If the design is a bracelet or anklet, simply wrap the toilet paper around once and tape the ends. If the design is on the hands or feet, then you must wrap the area in full like you would a mummy! Usually, the lemon-sugar solution will be fairly sticky and adhere to the paper, which is good because it will be less likely to fall off even if you toss and turn. If the design is on the back or stomach, simply make a patch out of toilet paper and place it over the area, Scotch taping the edges to your skin.

Razors

If there is hair or fuzz on the area where the henna is to be applied, it is best to shave it off in one direction before you begin. Henna deposited on hair will just sit on the hair and never fully penetrate the skin.

RIGHT: It takes time, patience, and creativity to achieve a detailed design such as this Moroccan hand in the making.

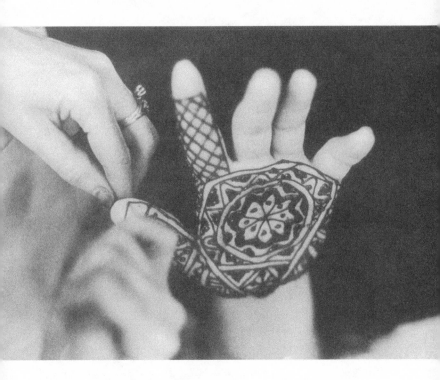

mehndi application

❋ **1.** Before you begin, have the following supplies ready and
❋ close at hand:

- Henna paste/applicator
- Eucalyptus oil
- Cotton balls
- One small bowl filled with a mixture of lemon
 juice and sugar ($^1/_2$ lemon to 1 teaspoon sugar or
 2 tablespoons concentrated lemon juice to
 1 teaspoon sugar)
- Paper towels, supply of cotton swabs, and
 flat toothpicks
- Straight pins

2. Shave off any hair from the area to be painted.

3. Once you have chosen the design you want, wash and dry the area to be painted or use a hot wet towel to rub the area vigorously. This serves two purposes:

First, you are removing all lotions, oils, suntan lotions, or sunscreens from the skin, all of which act like a barrier for henna. If these are not removed prior to application, the henna will eventually slide off and you will obtain absolutely no color!

Second, you are scrubbing off old dead layers of skin, which eases absorption of the henna into the skin.

4. Dip your fingertip into eucalyptus oil and gently massage a drop or two into the area to be painted.

5. Apply the henna design (see "Technique and Illustration Exercises," page 57).

6. Use cotton swabs and toothpicks to smooth out lines or fix mistakes when needed. Use paper towels for wiping excess henna off toothpicks. Use straight pins to clear out metal tips should they become clogged with henna.

7. Once the application of the design is completed, relax while the henna dries. This should take no more than 10 to 15 minutes, but the amount of time will vary depending on the skin type, so keep an eye on it. Henna should dry to the point where it looks flat, as opposed to shiny and wet, but not to the point where it starts to crack.

8. Once the henna dries, dip a cotton ball into the bowl mixed with lemon juice and sugar and gently dab the solution onto the design. Do this throughout the day to provide moistness and stickiness, which will help the henna design adhere to the skin. You will notice that the henna will dry

quickly and that you will need to dab it with this solution quite often at first. After an hour or so, you will notice that the henna paste will turn black and glazy. This means it is staying moist on its own and no longer needs to be dabbed as often. But keep an eye on it anyway. If you are going to be out and about, soak a cotton ball with the lemon-sugar solution and carry it with you in a sandwich bag so that you can continue to moisten your design every once in a while throughout the day. Be careful not to smear the area.

Heat and moisture are key to proper penetration of the henna into the skin! In addition to dabbing with the lemon-sugar solution, stay warm! Drink hot tea. Hang out in the sun, place yourself in front of a heater, or use a hair dryer or heating lamp.

9. For best results, the henna paste should be left on the skin for 12 to 20 hours; the longer, the better.

10. To remove the henna, dampen the paste with a cotton ball dipped in olive oil or any other *vegetable oil.* This helps to loosen the paste so that only the cotton ball rubbed on the skin in a vigorous fashion should be all you need to do to get it off. The oil also helps to boost the color. If there is stubborn residue, use the dull edge of a knife to get it off. *Please note: The color you see just after you take the henna paste off will deepen almost by 50 percent the following day.*

11. For the first 4 or 5 hours after removal of the henna paste, avoid wetting the area. If possible, it is best to keep the area away from water for one full day.

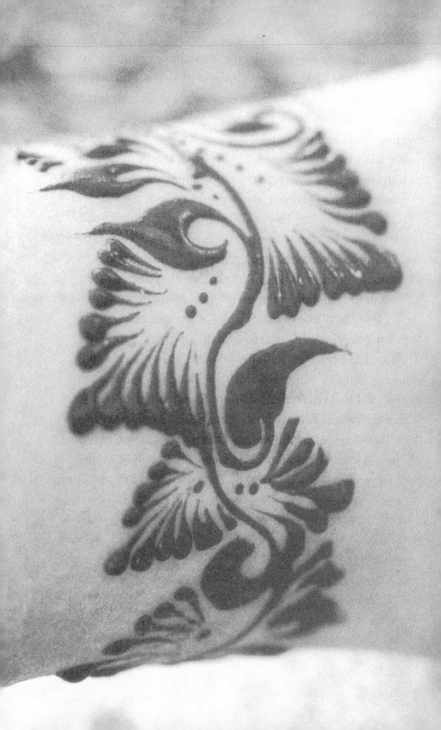

Technique
and
Illustration
exercises

For those of you who don't already know how to draw, becoming a mehndi artist will take some practice, but with these easy-to-follow exercises, it's not hard to do. You are probably tempted to start painting designs on yourself and friends *right now*, but it's smart to use a pencil on paper first.

Since making henna is a time-consuming process and the finished product has a short life span, it should not be wasted! After making a few sketches with a pencil, I highly recommend using toothpaste for trial runs on the skin. Toothpaste has a very similar feel to the henna texture and consistency you want to achieve. If you practice with toothpaste on paper and then on your skin, and then move onto henna, you will avoid dyeing your skin during the experimental stage, and will achieve far more satisfying and visually pleasing results.

1. Use several sheets of lined paper with ½-inch rows. *Please use a pencil at first and pretend it has no eraser.* Do not erase your mistakes. Henna starts to dye the skin right away, so it is best to get the hang of making lines with the idea that you can't correct them.

2. Using illustration 1 as a guide, practice drawing straight lines next to each other in a row. They should be parallel and fill the row from top to bottom. Hold the pencil from the top like you would a cone or bottle so that you get the feeling of using a henna tool. Next, practice drawing straight lines

- **at a slant**
- **in a curve**
- **in an S formation**
- **in a spiral**
- **in a circle**
- **in a heart shape, first drawing just the outline, then graduating to the inside of the heart, following its shape until you reach the center**
- **in a diamond shape, as above**

Practicing these lines will give you the "feeling" of drawing the lines that make up an actual design. Once you can master these lines with ease, making designs such as the two shown in illustration 1A will come naturally. But don't practice these designs yet! Practice the lines shown in illustrations 1, 2, 2A, and 2B before moving on to the design in illustration 3. Practice drawing the designs in illustration 3 before moving on to illustra-

PREVIOUS PAGE: A graceful anklet, which can also be done as a bracelet or an armband.

tion 4, which shows different combinations of all the lines practiced in 1, 2, 2A, 2B, and 3. It should take you at least 1½ hours to practice just these first three steps. Hint: When drawing right angles, you must move *your own hand*, not the paper, and later, not the person's hand on which you are working.

3. Designs should always be given a dark outline first before beginning the process of creating the design itself or filling in with detail. See illustration 3 for good examples of dark outlines for designs. Practice the outlines shown in illustrations 5 and 6 before continuing. Once the outline is done, you will want to practice filling it in with basic designs, such as the ones shown in illustrations 7 and 8.

4. Once you have spent some time practicing the previous steps, you can move on to fancy border designs, such as the ones shown in illustration 9. These illustrations are also representations of simple finger designs as well as bracelet and anklet designs.

5. Once you have mastered the simpler border/finger designs, you can go on to practicing the more complex finger/bracelet and anklet designs shown in illustrations 10 and 11. You will note that these more complex designs incorporate the simpler designs shown in illustrations 9, 10, and 11.

In all the previous examples, the idea is for you to master the simpler designs. Once done, the more complex designs will come so easily you will wonder why you ever thought you couldn't do these intricate works.

The mehndi designs shown in illustration 12 are taken from actual *saris* and are fine examples of quite intricate border or bracelet/anklet designs for you to practice.

illustration 1

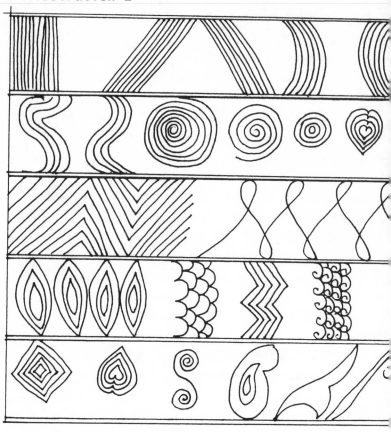

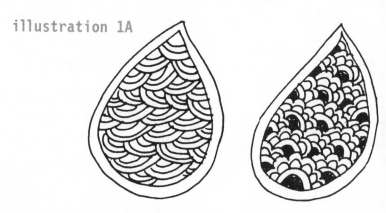

illustration 2

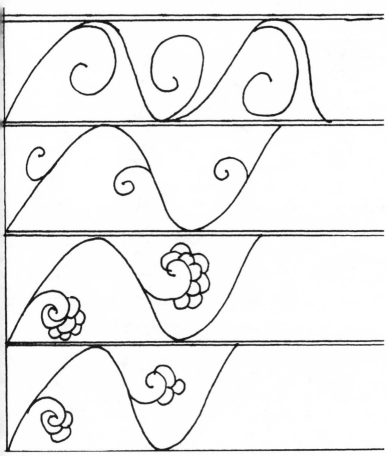

illustration 2A

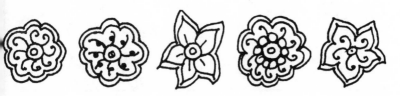

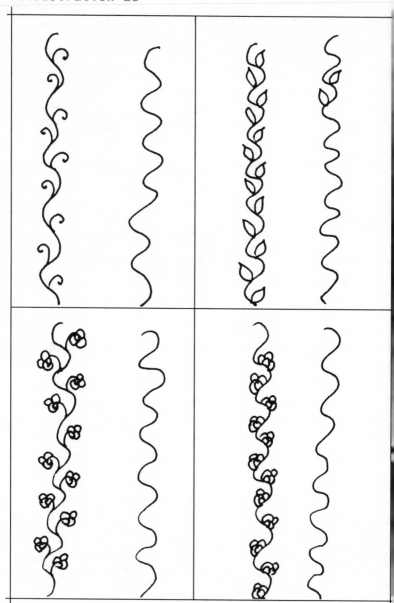

illustration 3

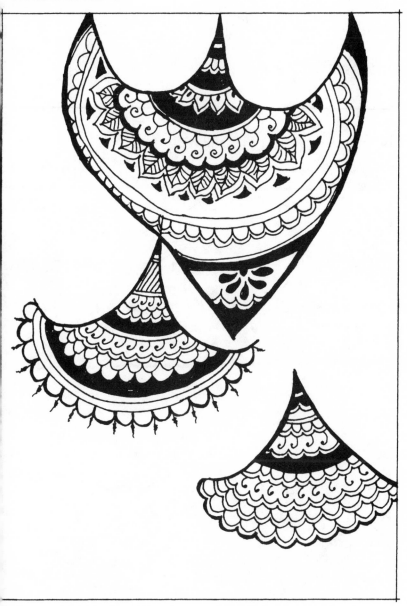

illustration 4

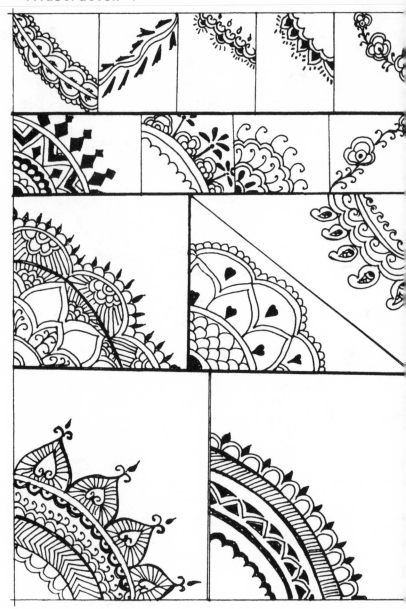

illustration 5

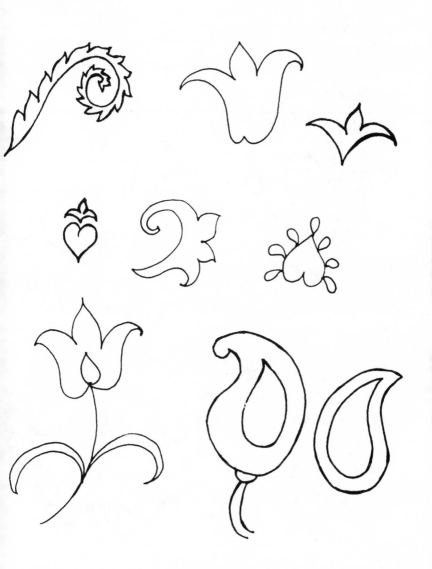

illustration 6

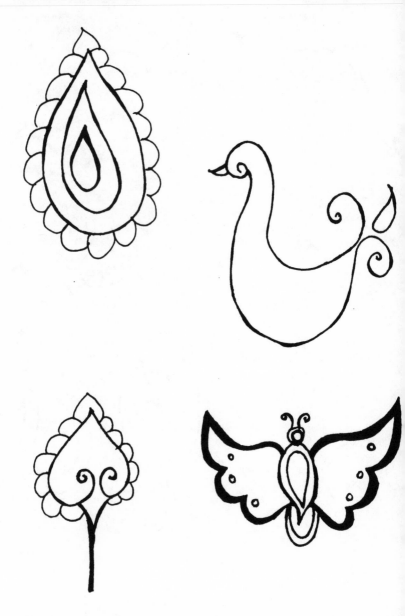

illustration 7

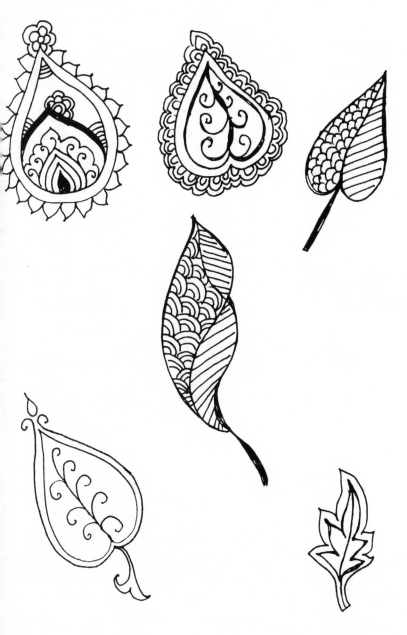

illustration 8

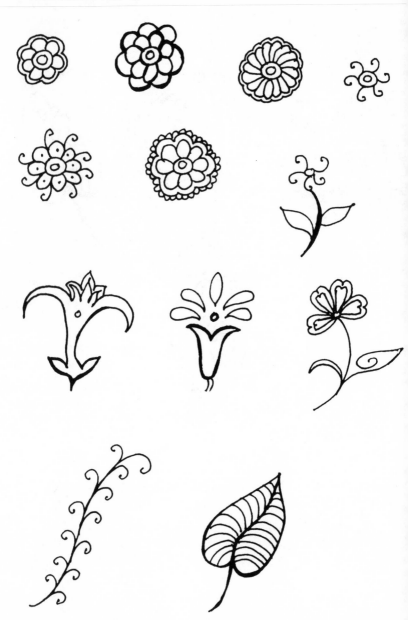

illustration 9

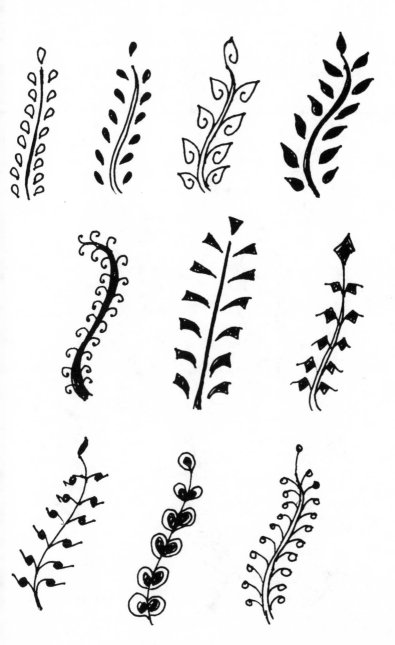

illustration 10

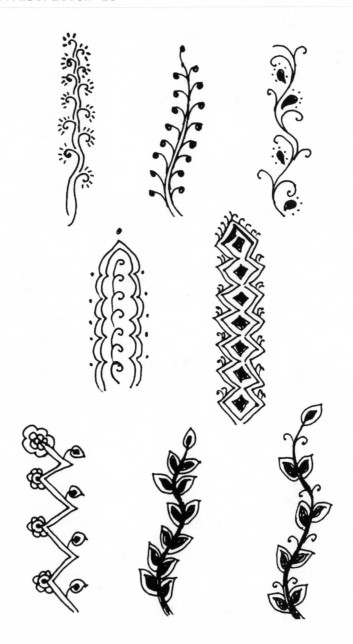

illustration 11

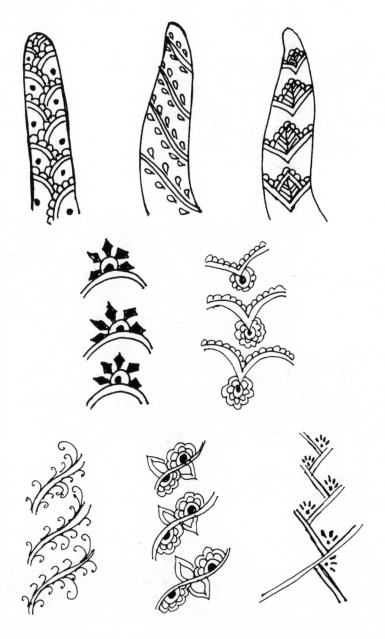

illustration 12

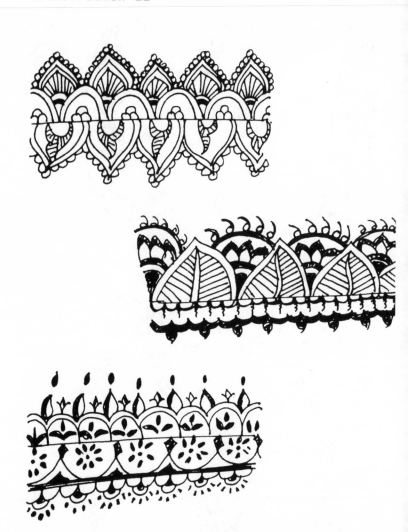

Once you have practiced these exercises with a pencil, you can graduate to practicing with toothpaste. Fill the cone or bottle with toothpaste to get a sense of how it feels to work with henna. Use toothpicks and cotton swabs to correct mistakes as instructed earlier. Repeat steps 3 through 5 until you feel proficient. Now you are ready to move onto the next level.

Take a blank piece of paper and trace the outline of your hand. Later you will want to repeat the process listed below by tracing your hand on the bottom of a rounded frying pan, as this method really helps you to get a handle on the natural shape of the hand. Using toothpaste, practice filling in the hand with designs incorporating lines in steps 3 to 5. You may practice copying illustrations 13 and 14 for actual hand and feet designs. Once you feel confident with the toothpaste, you are ready to use henna. Use your own hand to create designs of your choice. You may work from illustrations 13 and 14 or from any of the actual mehndi design photographs featured in this book.

But remember, if you can do the traditional Indian designs depicted in illustrations 13 and 14, achieving beautiful contemporary designs — which are usually less dense and are more like the ones created by the artists in our studio — will come naturally. Please refer to illustrations 15 to 18 for simple step-by-step breakdowns of such contemporary designs. Illustrations 19 to 22 have accompanying text, which is meant to give you an idea of a professional mehndi artist's thought process as he or she creates a design.

In addition, I have included two pages of popular and oft-requested symbols, along with their significance, which are easily applied mehndi designs. So get painting and have fun!

illustration 13

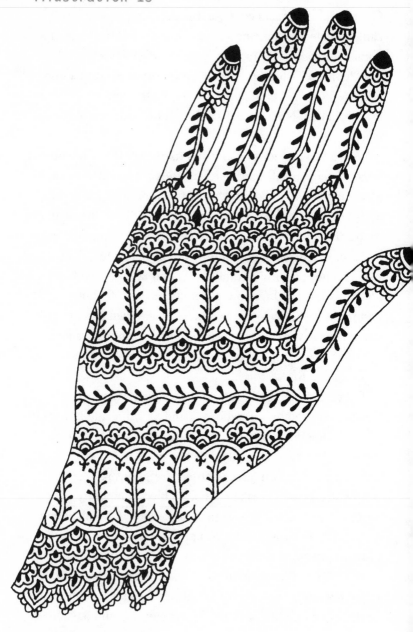

illustration 14

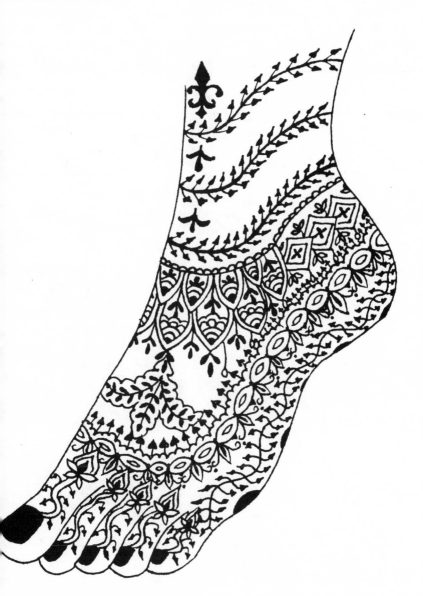

illustration 15

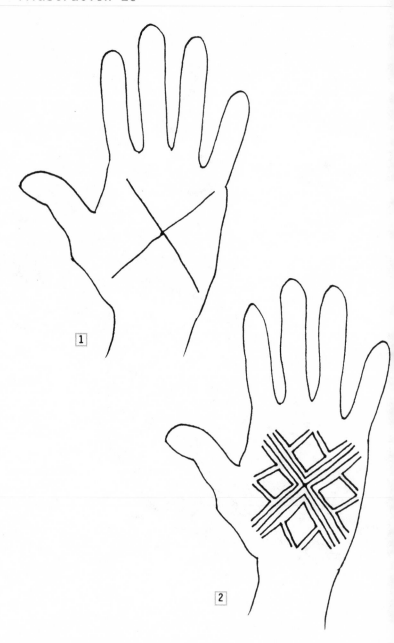

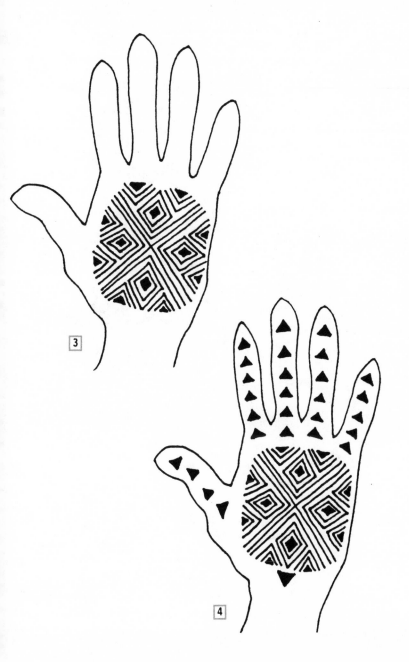

3

4

illustration 16

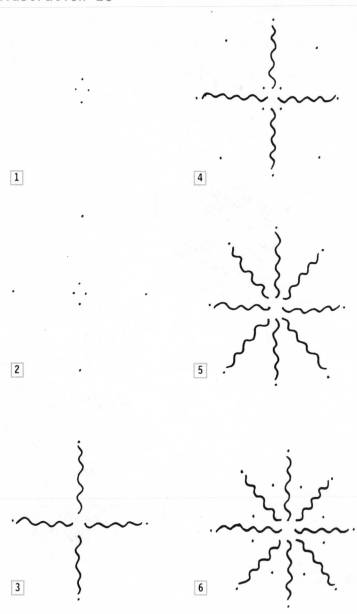

1

2

3

4

5

6

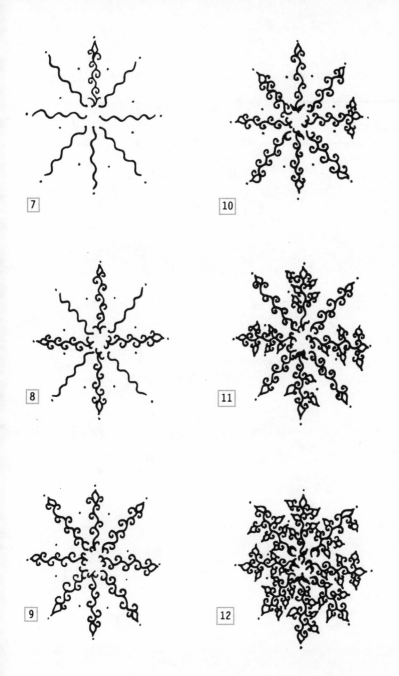

illustration 17

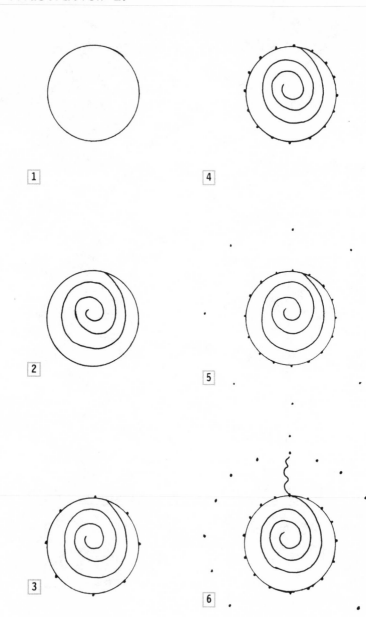

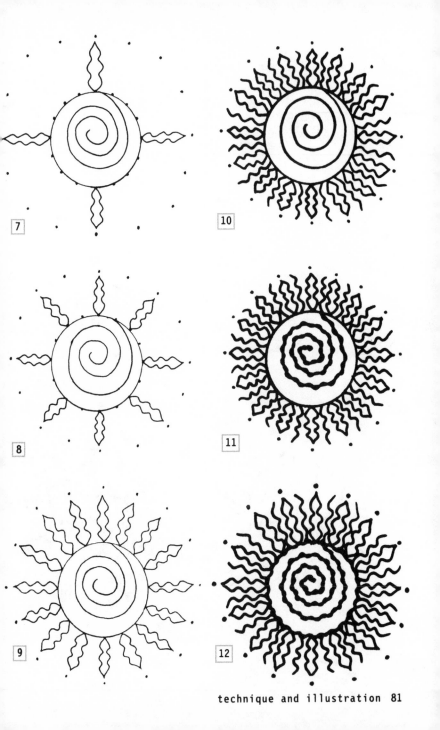

illustration 18

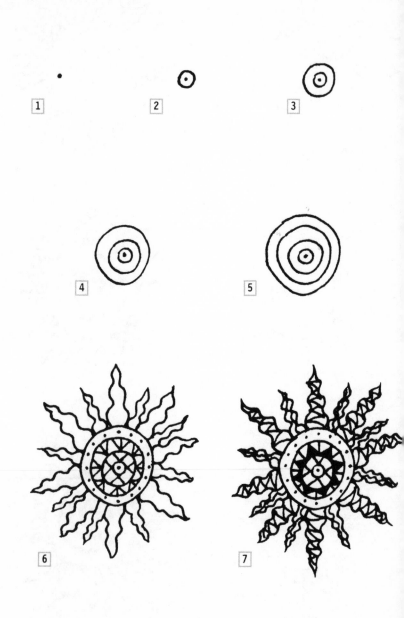

illustration 19

artist's thought process

Client wanted an abstract, universal symbol so a mandala came to mind. Started out with a center dot, then mapped out an eight-point axis; added dots and realized we were looking down at a flower. Tiny crosses seemed a natural extension. Dots connected to form the center of the flower, which naturally radiated outward. "Curlicues" at top of petals added dimension and softness. Crosses became stars as a final detail.

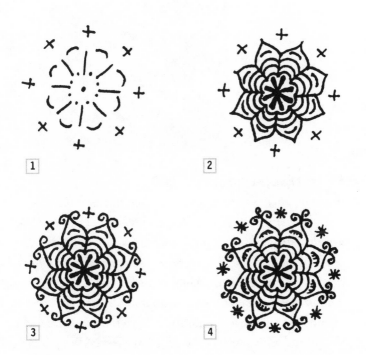

illustration 20

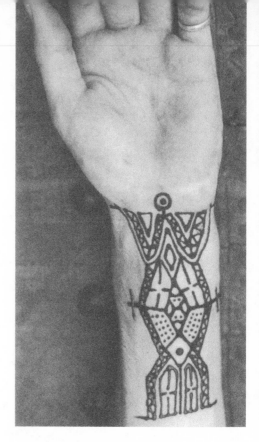

artist's thought process

Based on client's request for something spiritual, the idea for a person praying to the universe came to mind. The letter "W" was the perfect way to represent arms held up to the sky in prayer. Dot in circle at top represented head with emphasis on third eye. God's eye is diamond at heart chakra. Hourglass formation below represents eternity; hands outstretched suggest offering God's love to humanity, with feet firmly planted on the ground. Crisscrosses were added to outer edges of design to reflect a stained glass feeling, much like those of churches and temples. Cathedral doors at bottom completed the picture.

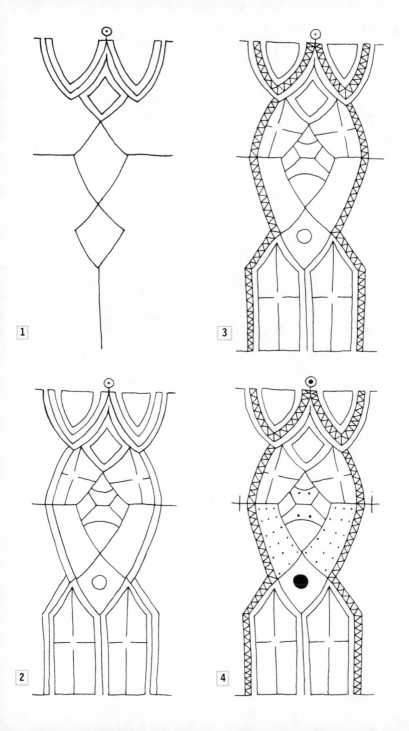

1

3

2

4

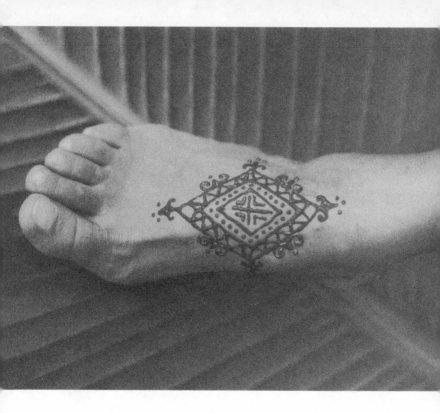

artist's thought process

Client wanted something tribal, but refined; feminine but not frilly. Came up with a diamond because she likes the stone. Crown centered the design just below the ankle. Turned crown into rosebud, added three more and made cross motif in center because it echoes diamonds. Scalloped edges softened design. Dots are a good way to add detail and a jeweled effect. Added curls, lotus petals, and clouds as final touches.

illustration 21

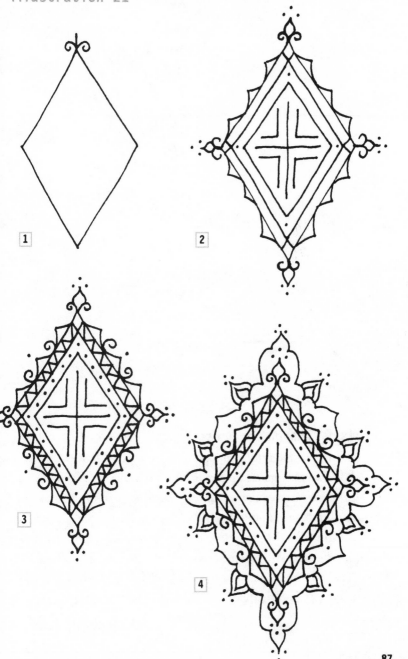

illustration 22

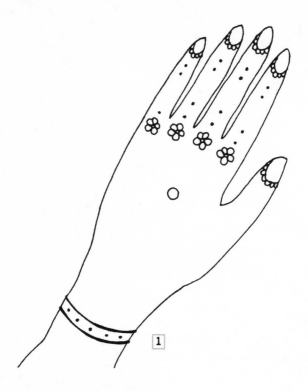

artist's thought process

Client wanted a hand design and announced that she liked flowers, stars, waves and geometric shapes. Started out with a small circle to center the design. Turned nails into flowers by adding petals around them; followed through with the idea on the knuckles. Made a simple bracelet. Zigzagged lines added playfulness. Waves added movement to fingers. Developed center circle into a star shape and added fantasy flowers to mirror client's free-spirited nature.

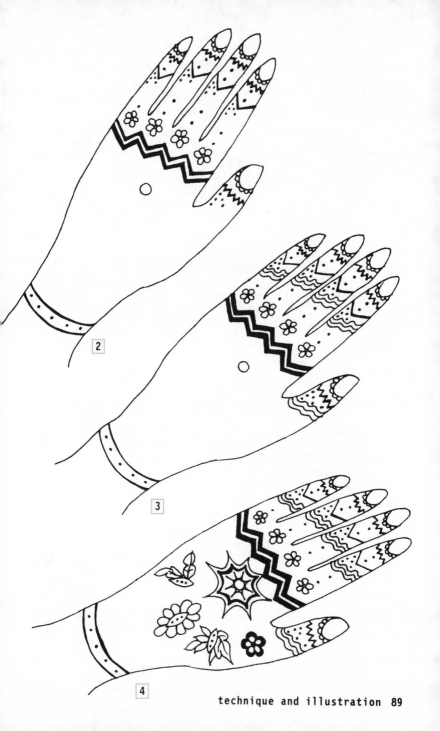

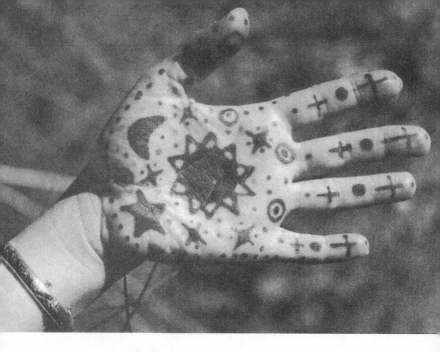

symbols

The sound of creation that holds the universe together. Brings inner peace and removes karma. *(Sanskrit/Persian)*

The quality of mind or spirit that enables one to face all circumstances with self-possession, confidence, resolution, and bravery. *(Chinese)*

Inner contentment, serenity; state of tranquility; harmonious relations. *(Chinese)*

Peace

Symbol of fertility and of the gift of eternal life. The design depicts the sun, sky, and the earth. *(Egyptian)*

Ankh

Oldest form of the cross from the Goddess temple in Malta. It symbolizes the four directions from the word's axis. Wearing a cross balances energy and centers.

Maltese Cross

Eye of Horus, "Eye of the Hawk"—considered to be protective, especially when both eyes are worn. *(Egyptian)*

Solar : Male

Lunar : Female

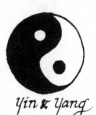

Symbolizes the union and balance of opposites. Harmony. Movement of creation through time and space. *(Chinese)*

Yin & Yang

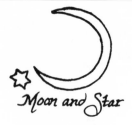

Moon and Star

Diana, Sister to Mother Earth, the feminine moon which regulates the tides, women's cycles, and growth of plants. The guiding light in times of darkness. *(Universal)*

Represents Love Goddess Erzulie Freda who is a great female spirit and governess of love. Emotional healing, creativity, and imagination. *(Haitian)*

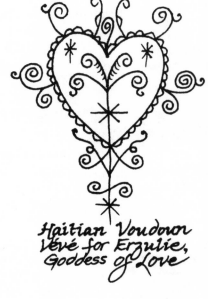

Haitian Voudoun Vévé for Erzulie, Goddess of Love

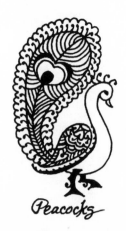

Peacocks

Symbol of love, passion, luck, protection, and prosperity. *(East Indian)*

practical considerations

Before you begin to apply the mehndi, decide on the theme of the design, flowers, vines, geometrical shapes, etc. It is also important to consider the body part you're working on; here are some general guidelines for different parts:

Hands and Feet

• When creating a design on someone's palm, think about the hand being divided into three parts. The palm is the best place to start, as it is much more complex than a flat surface like a stomach or back. If you can do a hand or a foot, the rest is simple.

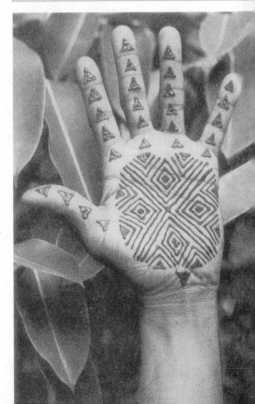

BELOW: A bold contemporary geometric palm design reminiscent of the traditional Moroccan style.

The following divisions are important to note and follow:

a. The inner wrist, where it bends, to the thumb line—at the top of the thumb—is the first division and the place where you should start.

b. The upper thumb line to the line where fingers start is the second division and is considered the main part of the design. The thumb is included as part of the main design.

c. The four remaining fingers are considered the third division and should be done last.

• Keep in mind that when you create a design on someone's hand, it is important that you start from the wrist, working your way down to the *left-hand side* of the hand *first* to finish the design on the right side of the hand or fingers last. This makes it possible for you to hold the person's hand on the right, or to lean on the right side of the person's hand for support as you work to complete the design.

• When doing a design on someone's feet, you should consider that three fingers' width above from where the ankle bends is where the main design begins; the line where the toes begin is where the main design ends. For best results, paint the main design area first. Move on to the inner side of the foot and continue the design there; then go on and to the outside of the foot and complete the design there. Toes should be done last.

The best way to position a person if you are working on their feet is to have them stand with their foot placed up on a stool or tabletop. This will give you better angles to work from, you will be able to move around the person more easily, and you won't have to lay down on the floor when painting the sides of their feet!

RIGHT: Hand designs, even on the same person, do not have to be identical.

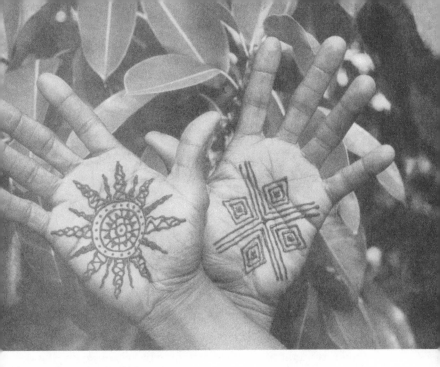

Tips on Technique

• When creating a design on someone who would like to have both hands and feet painted, do the palms first, then the feet. By the time the feet dry, the palms should have already been dabbed with the lemon-sugar solution and they should already be dry. Working in this order allows you to place tissue paper (i.e., toilet paper) on the person's palms; this allows them to set their hands down either on your lap or on the flat of your hand so that you can then begin the work on the tops of their hands. If the left palm was painted first, the top of the left hand should be done first as well.

• Traditionally, both hands do not have to be painted identically, while the feet do. The very simple reasoning behind the custom is due to the fact that hands naturally hang down opposite sides of the body so that each hand is

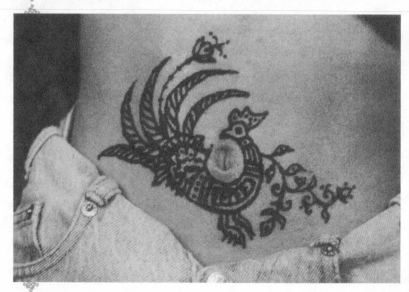

often seen separately. However, feet are always seen together and should therefore have matching designs. Usually, hand designs are delicate while feet designs are bold because feet are often seen from a distance.

• Someone wanting both the tops and palms of their hands painted should be advised of the inconvenience of having both palms done on the same day. Although the tradition in India and North Africa is to have brides painted on both sides, keep in mind that the bride-to-be is completely coddled during this time. She won't be expected to drive to the grocery store, for example, or to cook or to feed herself. And just try using bathroom facilities without the use of your hands. It is advisable for people to have all but one palm painted in these cases, which palm can get done the following day. If the person insists on having everything done at once, try to keep the tips of the fingers (palm side) free so that they will at least have some usage of their hands.

The Back and Stomach

• The choice between a delicate and lacy design versus bold designs using thicker lines is important to consider when painting a back or a stomach, as well. Keep in mind that these designs will often be seen from a distance, and if they are too lacy or viney, they will tend to look like the person has some rare skin disease rather than a dainty mehndi design.

In addition, should someone want you to paint a design on their back *and* on their stomach, if you are using fresh henna preparations, which need to be left on overnight, you should advise them against it. No one can sleep standing up or sideways all night, and one or the other of the designs will get smeared. The same concept applies to those wanting a garland or beltlike effect that goes all the way around the stomach. You should advise them to do one side of the body one day and return for the other side the following day.

Nape of Neck

• If you are painting the back-of-neck area, do not create the design directly on the area where the person's neck bends. They will never be able to keep their heads straight for the number of hours required and the dried henna will flake off. Most people will understand this and accept that the design be applied in the area just below.

LEFT: **The peacock on this stomach is a symbol of love, luck, and prosperity.**

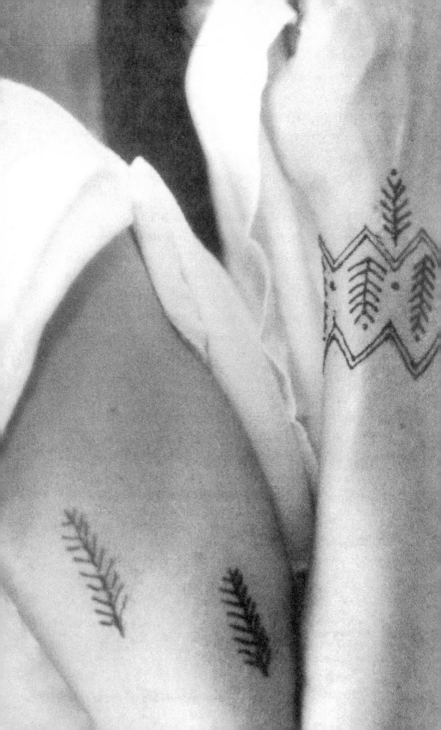

Rhythm

• A design must have rhythm. In order for the design to have grace and beauty, there must be a rhythm to the lines and flow of the design. You wouldn't mix geometrical shapes with flowers, for example. If you do decide to mix square shapes with circular ones, think of making a link that flows somehow from one form to the next.

• And speaking of rhythm, the body has one, too. For example, when you paint a stomach or a back, the person will be breathing. It is important for you to try to follow the natural rhythm of the breath and to move your hand accordingly.

Tips from Professional Mehndi Artists

1. When creating a mehndi design, put the weight on your pinky to balance yourself. This way your hand doesn't touch the henna.

2. Keep a design book for working out complicated designs, and to sketch out design elements that come to you on a day-to-day basis. This is also a great way to keep favorite designs all in one place.

3. Practice on skinned fruits, such as oranges and bananas, to get a feel for lines and how they change on three-dimensional surfaces.

LEFT: This mehndi artist designed a tribal wristband and repeated the theme on the arm.

4. Make sure to relax your arms, shoulders, and neck as you work, and try not to hunch your back for long periods of time.

5. Have the area you are working on as close to eye level as possible.

6. It is always easier to pull your lines toward you, than to push them outward. It offers greater control.

7. Have your client relax the body part to be painted, and let it hang or rest as naturally as possible.

8. When mehndi is done with intent or purpose, the color always comes out stronger and more beautiful. Placing henna on your body is like putting out a wish to the universe. For example, if you are creating a design which symbolizes fertility, luck, prosperity, or luck on yourself, or on a client who desires any of these blessings, the color of the design is always deeper, more intense. So, for best results, keep the mehndi gods in mind!

RIGHT: This stunning mehndi design incorporates traditional Indian elements with a contemporary flair.

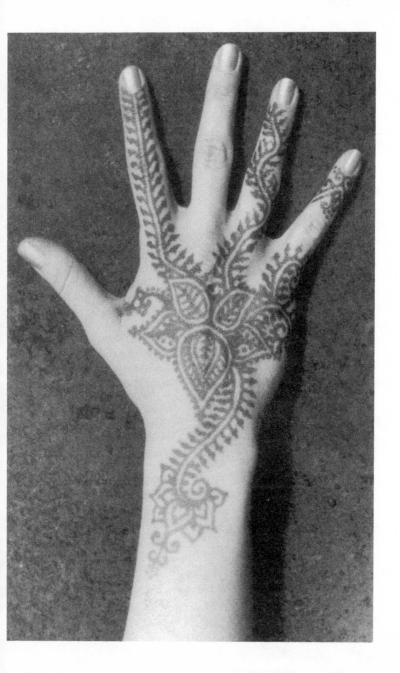

Mehndi Artists, Salons, and Suppliers by State

california

Carine Fabius
Lakaye Studio
1800 N. Highland Avenue, #316
Hollywood, CA 90028
(323) 460-7333
For orders: (800) 224-5600
information@earthhenna.com
www.earthhenna.com
*Artists/Tools, supplies, design books
for sale/Henna kits for sale featuring
henna with a long shelf life*

Bakari and Leticia Santos
Los Angeles, CA
(323) 857-0523
Artists

Ziba Beauty Center
18500 S. Pioneer Blvd., Suite 203-204
Artesia, CA 90701
(562) 402-5131
Artists/Henna cones and kits for sale

Jayshree Nensey
Los Angeles, CA
(626) 332-8843
nensey@earthlink.net
Artist, teacher, design books for sale

Michael Kraemer
Thirteen B.C.
7661½ Melrose Avenue, Suite 1
Los Angeles, CA 90046
(323) 782-9069
Artist/Tattoo and piercing shop

Joyce Kingsbury
The Body Arts Company
323 E. Matilija
Ojai, CA 93023
(805) 646-1120
For orders: (800) 300-9901
*Artist/Henna, designs, book, and kits
for sale*

Antoinette Zagata/ Tiffany Germaine
San Francisco, CA
(415) 488-0273

Kavita Goyal
San Francisco, CA
(415) 621-7751
Artist/Teacher

Phoenix and Arabeth
Ukiah, CA
(707) 462-6674
Henna artist

Krysta and Cheri
Beauty and the Beach
120 Ruby Street
Redondo Beach, CA 90277
(310) 316-6976
Artists

Debrae
1069 Summit Road
Watsonville, CA 95076
(Santa Cruz–Carmel area)
(408) 848-1117
Artist

Judy Canastrelli
Los Angeles, CA
(323) 467-6828
Artist ·

Gabriela
Los Angeles, CA
(323) 666-1827
Artist

Lori Hunt
Los Angeles, CA
(323) 828-6466
Artist

Ayesha Jones
Los Angeles, CA
(213) 381-7027
Artist

Erin McLaughlin
Los Angeles, CA
(323) 969-2497
Artist

Liza Vosbigian
Los Angeles, CA
(310) 840-5560
Artist

Sandy Z.
Los Angeles, CA
(323) 737-3782
(310) 210-8742 cell/pager
Artist

Akasha Nilson
San Rafael, CA
(415) 456-4369
Artist

Cola Smith
Los Angeles, CA
(310) 837-3132
Artist

colorado

Mehndi
Aspen, CO 81611
(970) 544-9944
Artist

Kathy Niceforo-Nilson
Sacred Body Art
(303) 545-6240
Artist

Carrie Russell
Red Veil Mehndi
P.O. Box 20873
Boulder, CO 80308-3873
(303) 641-0477
E-Red_Veil@hotmail.com
Artist

kentucky

Paula O. Whitaker
Pow Art
210 Burke Road
Lexington, KY 40511
(859) 259-1439
Artist

Lucia Terrell
Taylorsville, KY 40071
(502) 477-5770
Artist

louisiana

Ruby Moon
New Orleans, LA 70121
(504) 733-8469
Artist

new jersey

Wendy
Body Graphics
(215) 922-2669
Artist

Halima Abdul-Ghani
The Henna Lady
528 Leo Street
Hillside, NJ 07205
(908) 686-9528
HANDDANCE@hotmail.com
*Artist/Specializes in Sudanese-style
designs*

Susan Sarao
Transformations
21 Godwin Avenue
Ridgewood, NJ 07450
(201) 612-8022
Artist

new york

Rani Patel/Nishit Patel
New York, NY
(888) HENNA ME
*Artist/Instructor: Rani Patel
Henna powder, sales in bulk or by th
pound: Nishit Patel*

Mollie King
New York, NY
(212) 358-3488
Artist

Erin McLaughlin
New York, NY
(917) 721-2461
Artist

texas

Dutch Dalton
Tattoo Ice
5627 Bell Avenue
Dallas, TX 75206
(214) 887-1269
Artists

Alain Angelos
Carmen Hair Salon
5857 N. Mesa, #15
El Paso, TX 79912
(915) 581-3363
Artist

utah

Melanie Larsen
Melanie's Mystic Mehndi
45 W. 1600 N., #2
Sunset, UT 84015
(801) 298-2432
Artist

Jennifer Lucas
Orem, UT 84057
(801) 367-2411
Artist

canada

Urban Primitive Body Design
216 Carlton Street
Toronto, ON M5A21L
(416) 966-9155
Artist

bibliography

Collier's Encyclopedia. Volume 12, page 39. New York: P. F. Collier, L.P., 1996.

Edwardes, S. M. *Mughal Rule in India.* C.S.I., C.V.O. and H.C.O. Garrett, M.A. Oxford University Press, London: Humphrey Milford, 1930.

Encyclopedia Americana, International Edition. Volume 14, page 93. Danbury, CT: Grolier Incorporated, 1994.

Garcia, Michèle Maurin. *Le Henné — Plante du Paradis.* Geneva, Switzerland: Edito Georges Naef SA, 1992.

Jereb, James F. *Arts & Crafts of Morocco.* Chronicle Books in U.S., 1996; Thames and Hudson Ltd. in Great Britain, 1995.

Phoenix & Arabeth. *Henna (Mehndi) Body Art Handbook — Complete How-To Guide.* Phoenix & Arabeth, 1997.

World Book Encyclopedia. Volume 9, page 185. Chicago: World Book, Inc., 1996.

suggested design books

1. *African Designs of the Congo* by Caren Caraway, Stemmer House Publishers, Owings Mill, MD, 1986.
2. *African Designs of the Guinea Coast* by Caren Caraway, Stemmer House Publishers, Owings Mill, MD, 1986.
3. *Big Book of Graphic Designs & Devices* by Tipony, Inc., Dover Publications, Mineola, NY, 1980.
4. *Decorative Symbols and Motifs for Artists and Craftspeople* by Flinders Petrie, Dover Publications, Mineola, NY, 1986.
5. *Design Elements 3* by Richard Hora and Mies Hora, The Art Direction Book Company, New York, NY, 1982.
6. *Design Motifs of Ancient Mexico* by Jorge Enciso, Dover Publications, Mineola, NY, 1953.
7. *Folk Designs for Artists and Craftspeople* by Ed Sibbett, Jr., Dover Publications, Mineola, NY, 1977.
8. *Handbook of Designs and Devices* by Clarence P. Hornung, Dover Publications, Mineola, NY, 1946.
9. *Stencil Alphabets/100 Complete Fonts from the Solotype Archive*, selected and arranged by Dan X. Solo, Dover Publications, Mineola, NY, 1988.
10. *Symbols, Signs & Signets* by Ernst Lehner, Dover Publications, Mineola, NY, 1950.
11. *Traditional Chinese Designs*, edited by Stanley Appelbaum, Dover Publications, Mineola, NY, 1987.
12. *376 Decorative Allover Patterns from Historic Tilework and Textiles* by Charles Cahier and Arthur Martin, Dover Publications, Mineola, NY, 1989.

photography and illustration credits

index

A native of Port-au-Prince, Haiti, Carine Fabius arrived in
the United States with her family in 1964. She grew up in
New York City, where she became involved with the enter-
tainment industry when she went to work as an assistant edi-
tor in the Programming Division of CBS Television
Network. She later moved to Miami, Florida, taking a public
relations position with Phoenix Rising Productions, a film
production company. In 1986, Ms. Fabius moved to Los
Angeles, where she joined Josh Baran & Associates, a public
relations agency. In 1990, with her husband, Pascal Giaco-
mini, Ms. Fabius opened Galerie Lakaye, a Caribbean and
Latin art gallery with a focus on Haitian art. Over the years,
the gallery has been featured in prestigious publications,
including *Vanity Fair*, *Bon Appétit*, and the *Los Angeles
Times* (numerous times).

In January 1997, Ms. Fabius and her husband opened
Lakaye Mehndi Studio to introduce the art of mehndi in Los
Angeles. The overwhelming response to the art form inspired
the couple to take the next logical step, which was to make it
possible for others to offer mehndi in their establishments.
They accomplished this by creating "Earth Henna™," a revo-
lutionary new all-natural product that simplified the applica-
tion process by differing from the fresh henna mixture in
three important ways: it has a shelf life of four weeks when
refrigerated (as opposed to three days), it only needs to be left
on the skin for two to six hours (as opposed to twelve to
twenty hours), and it does not require the post-application
lemon-sugar solution. Although many people still like to

make up their own henna paste, the creation of this product serviced many in smaller cities where there were no Indian communities to provide the basics.

In addition, Lakaye Mehndi Studio also offers the "Earth Henna™ Body Painting Kit." These do-it-yourself kits, which are available in fine beauty supply stores, arts and crafts stores, and department stores, contain everything needed to perform mehndi at home, including henna powder and the liquid ingredients necessary to mix your own "Earth Henna™" paste, all the tools and supplies needed, including applicator bottles and tips, eucalyptus oil, reusable stencils, sample designs, and instructions sheets.

Ms. Fabius now divides her time equally between running Galerie Lakaye and Lakaye Mehndi Studio.